THE CAT

Artlist Collection
THE
CAT
™

www.thecat-club.com

THIS IS A CARLTON BOOK

This edition published in 2011 by Carlton Books Limited
20 Mortimer Street
London W1T 3JW

10 9 8 7 6 5 4 3 2

Material from this publication first appeared in a larger
edition in 2005

A CIP catalogue record for this book is available from
the British Library.

ISBN 978 1 84732 590 7

Printed in China

THE CAT

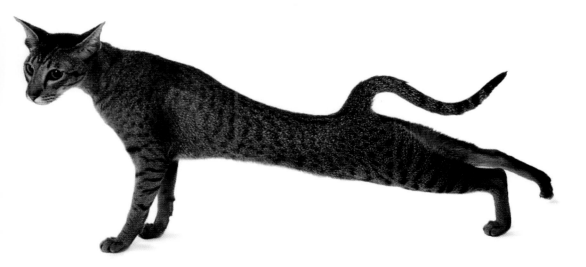

THE ORIGINAL · ACCEPT NO COPYCATS ·
THE CAT
Artlist Collection

CARLTON
BOOKS

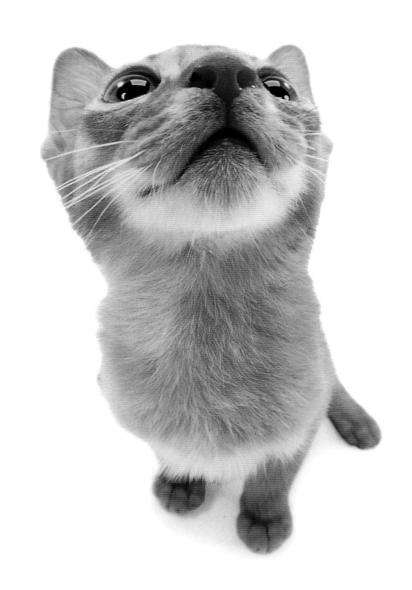

🐾 **Contents**

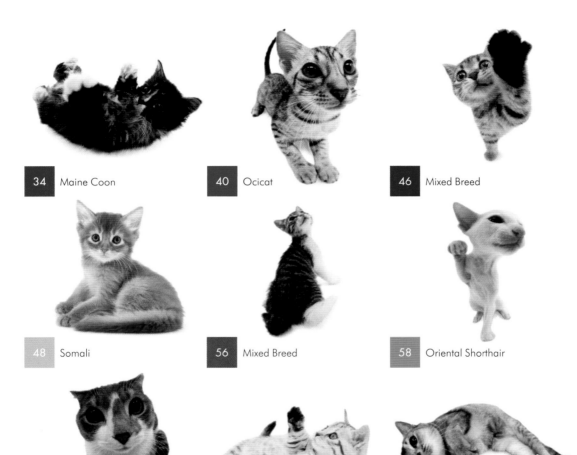

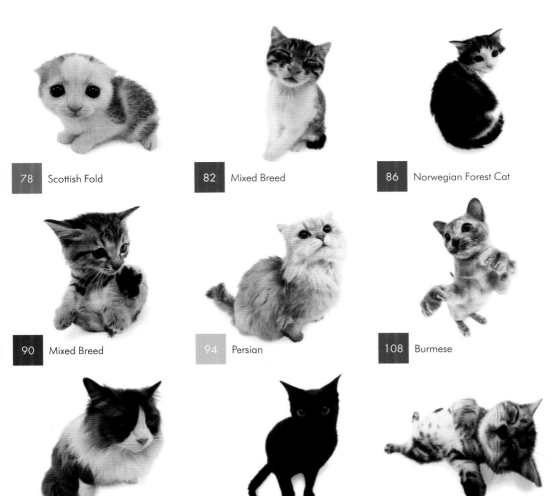

78 Scottish Fold

82 Mixed Breed

86 Norwegian Forest Cat

90 Mixed Breed

94 Persian

108 Burmese

114 Ragdoll

116 Mixed Breed

118 American Shorthair

Introduction

People have been keeping cats for thousands of years and today they are the world's most popular pets, yet one of their greatest attractions for us is that, even after all this time, we still don't really know them. Stare into their eyes and you can never be quite sure what you might see. Just try it with some of the pictures in this book. Sometimes there is a look of utter bewilderment, sometimes one so endearing it will melt your heart, and sometimes there is a faraway feral look that says, "I'm a wild thing. If you were smaller and I was bigger, I would eat you." If, over the course of time, cats have been domesticated, then maybe someone should have told them so!

In *The Cat*, "strange-ratio" photography – pictures taken using a fish-eye lens (showing 70 per cent head, 30 per cent body) – has been used to capture some of the essence of our favourite pets. More than 50,000 such images have been created as a springboard for the coolest new licensed property from Japan, and this collection shows you the very best.

Nothing creates an air of peace and tranquillity in your home like a contented cat snoozing in front of the fireplace. On the other hand, nothing can create absolute mayhem, shred your curtains and destroy your soft furnishings like a kitten that's just discovered its claws! Cats can be aloof, affectionate, excitable and serene all in less time than it takes to twitch a whisker. All of this and more accounts for our fascination with them, and when you look through this book, we challenge you not to go "Ahhhhhh…"

BENGAL

Although it sounds as though it should be directly descended from some kind of miniature tiger, the Bengal actually first appeared in America in the 1970s. A scientist at the University of California, who was studying disease resistance in the Asian Leopard Cat, bred these cats with others, eventually producing what became known as the Bengal. The university cats were passed on to Mrs Jean Mill, who had some experience with the Leopard Cat breed, and she registered the first of the Bengals in 1983.

In common with many American breeds, Bengals are large, muscular cats. The Brown Spotted variety most closely resembles its Leopard Cat ancestors. As a new breed, the Bengal is still relatively rare, but its soft, luxurious coat is so pleasing to the touch, and its affectionate nature so appealing, that anyone lucky enough to have one would surely never want any other breed.

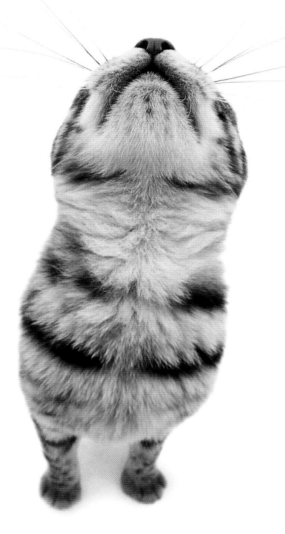

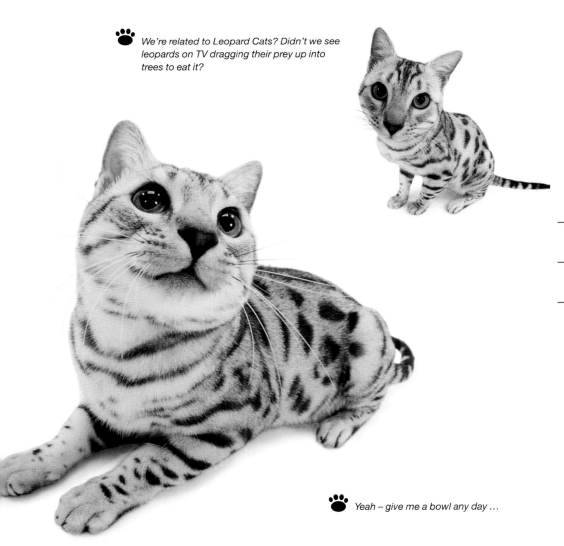

We're related to Leopard Cats? Didn't we see leopards on TV dragging their prey up into trees to eat it?

Yeah – give me a bowl any day …

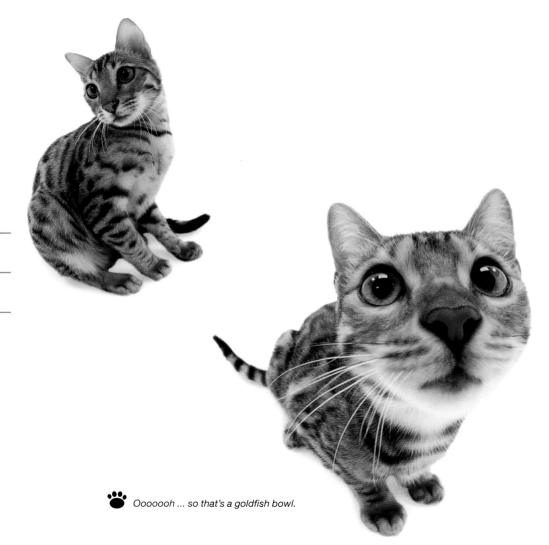

 Ooooooh ... so that's a goldfish bowl.

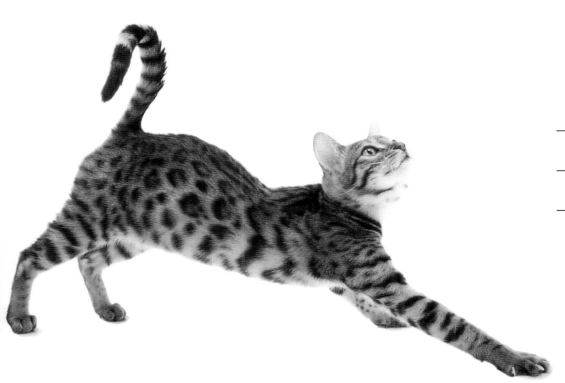

13

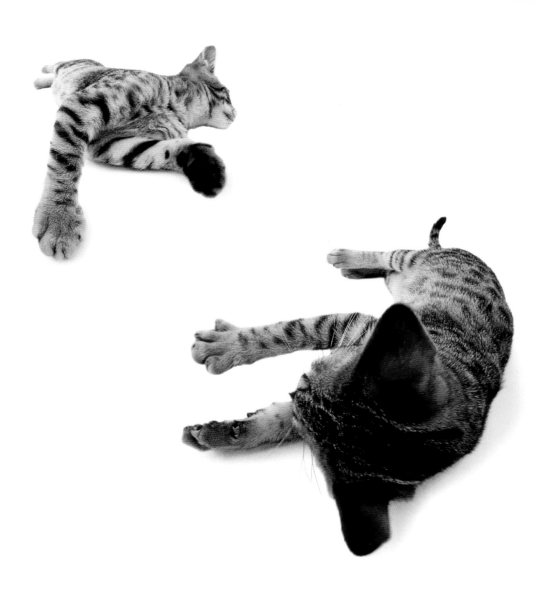

 With a bit of a run at it, I reckon I could make it straight up those curtains ...

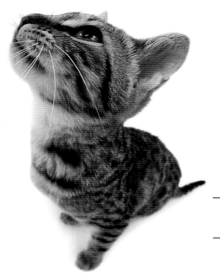

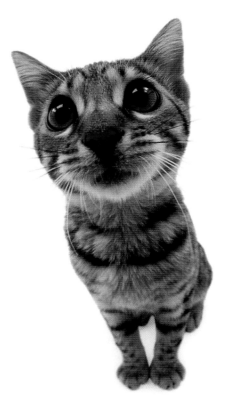

 Would that be such a bad thing?

SIBERIAN FOREST CAT

If you lived in Siberia, where the Soviet winter is famously long and cruelly cold, you would want a big, thick coat, possibly two, and that's exactly what the Siberian Forest Cat has got. The long, oily hair of its topcoat is designed to keep out the worst of the rain and snow while its dense undercoat blocks the fiercest of winds.

Of course, to carry two such heavy coats, you have to be big and strong, and the Siberian has a large muscular build, although its powerful physique does not prevent it from being both energetic and surprisingly agile. Because they are so well equipped for the great outdoors, Siberians do not feel entirely at home cooped up in a warm house. They can tolerate heat when it suits them and enjoy human company when they choose to, but they're not generally the sort of cats to keep you company on the sofa in the evening.

While Siberians have existed in Russia for many years, it was not until 1990, when enthusiasts brought them to America, that this imposing breed began to gain true recognition.

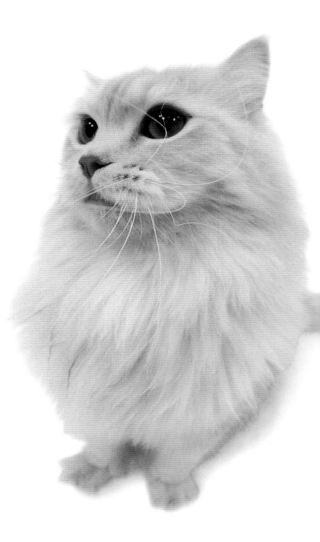

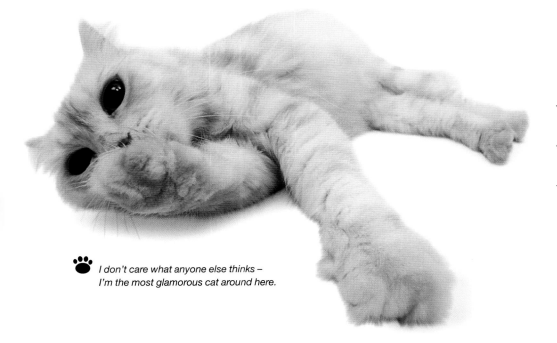

*I don't care what anyone else thinks –
I'm the most glamorous cat around here.*

RUSSIAN BLUE

The Russian Blue has been known variously throughout the years as the American Blue, Spanish Blue, Maltese Blue and the Archangel Cat, a name that betrays its true ancestry. These gentle, sometimes shy cats were brought to the West in the nineteenth century by sailors from the Russian port of Archangel, close to the Arctic Circle. They were believed to bring great good luck in Russia, where owning one was seen as something of a status symbol. One Blue, called Vashka, was the favourite pet of Tsar Nicholas II.

In all the time that these cats have been bred in the West, only one thing about them has changed. The original Blues had orange eyes, whereas the modern version has vivid emerald-green eyes. All-black and all-white versions have appeared, notably in New Zealand, but for the purists, only the beautifully lustrous, blue coat of the original will do.

 Is it milk time yet? I'm parched.

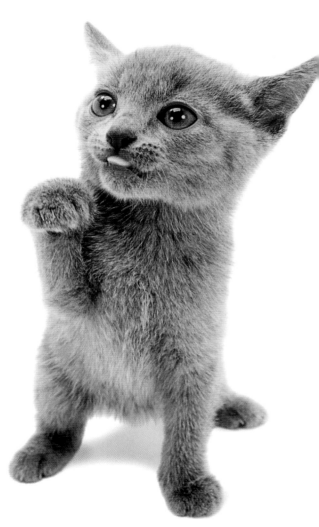

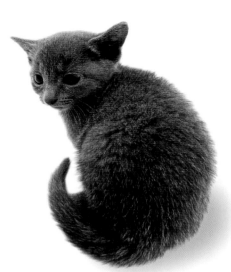

 You can tell by his twitches that he's dreaming about the giant purple mouse again.

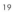

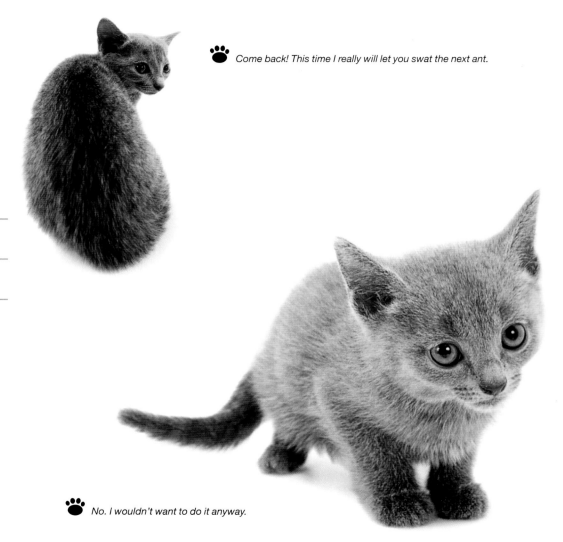

 Come back! This time I really will let you swat the next ant.

No. I wouldn't want to do it anyway.

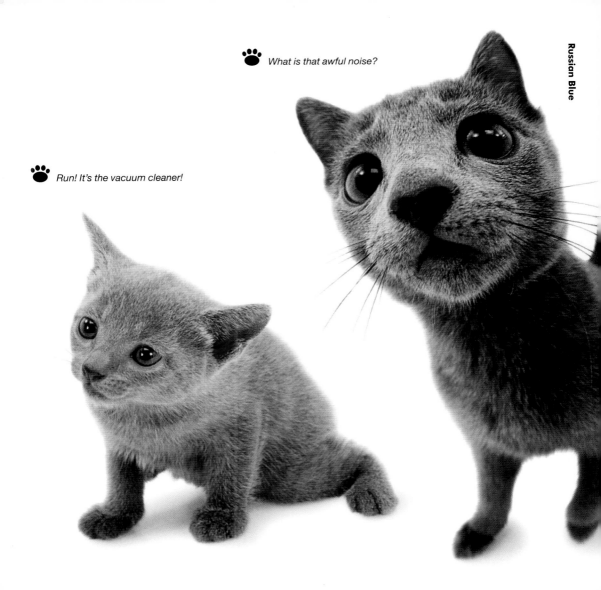

What is that awful noise?

Run! It's the vacuum cleaner!

Russian Blue

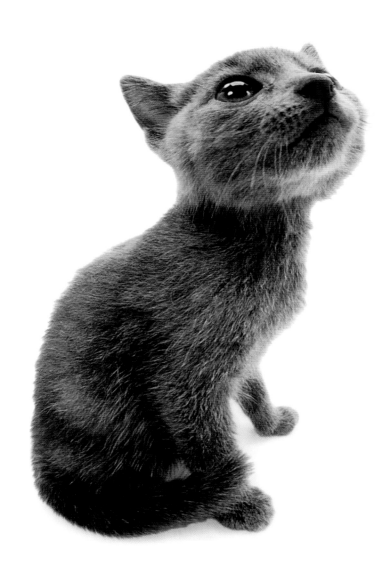

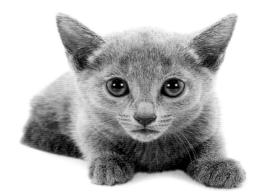

 Hypnotizing him was easy, but how do you do that wakey-wakey, finger-snappy bit?

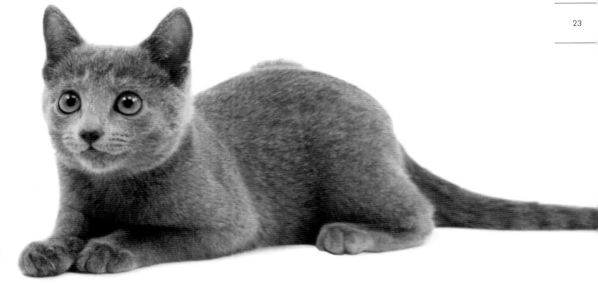

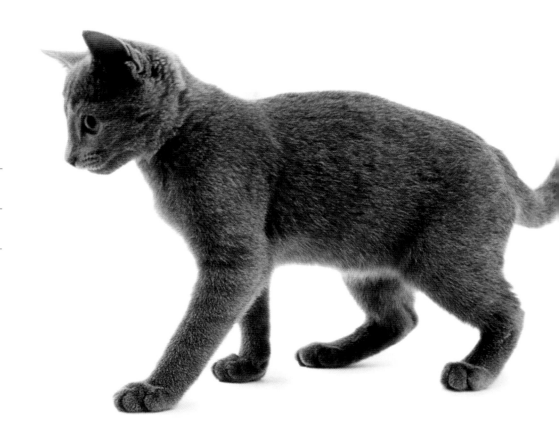

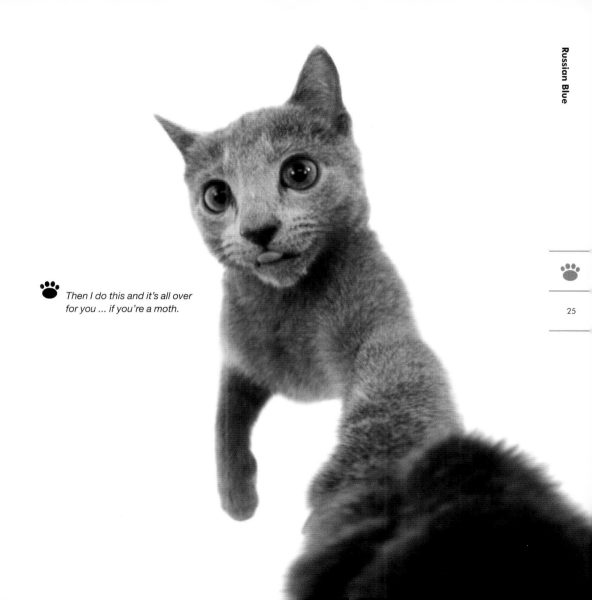

Then I do this and it's all over for you ... if you're a moth.

25

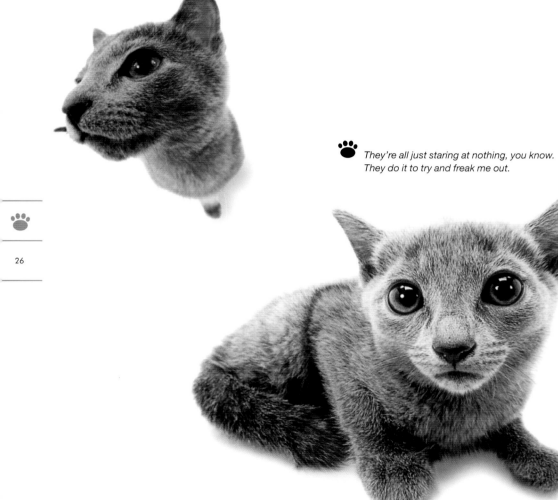

🐾 *They're all just staring at nothing, you know.
They do it to try and freak me out.*

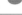

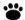

See? Spinning round in circles on the floor is cool!

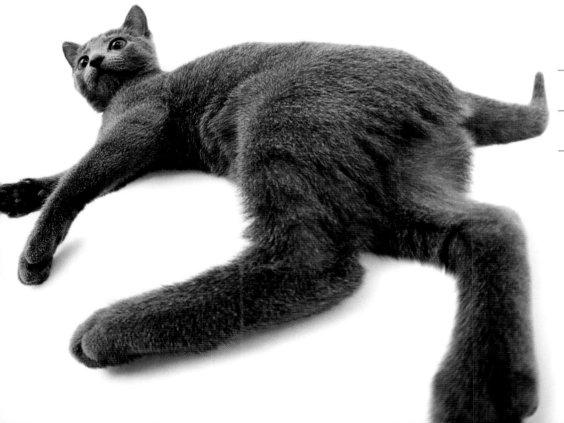

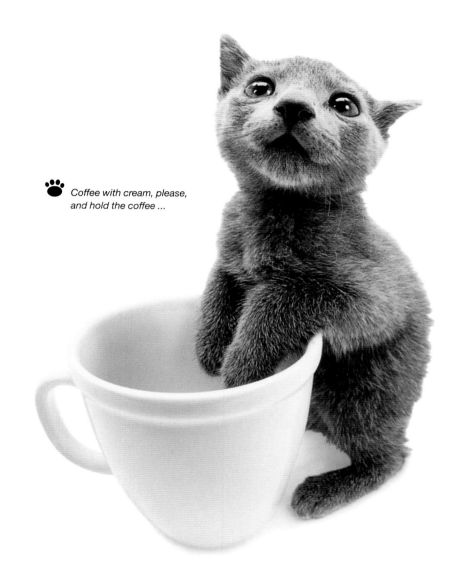

*Coffee with cream, please,
and hold the coffee ...*

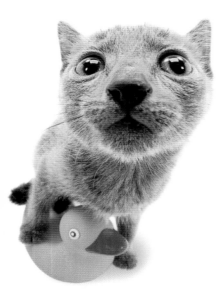

*I'll trade you a play with my duck
for ten minutes in your castle ...*

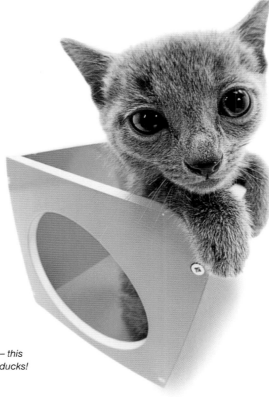

*He must think I'm crazy – this
castle is worth a million ducks!*

MARKING ITS TERRITORY

When you see cats rubbing themselves against a tree or a fence post, it might look like they're enjoying a good scratch, but they're actually leaving a message for all other cats in the area to say "I've been here" or "This is where I live".

Cats have scent glands on their heads, necks and near their tails, which leave a trace that other cats can smell. Your cats might lovingly rub themselves against you when you arrive home, but they are actually "marking" you, too. That's to tell other cats that you belong to them – and you thought that your cats belonged to you!

 Shiny floor or not, no one ever expects me to come shooting past like this.

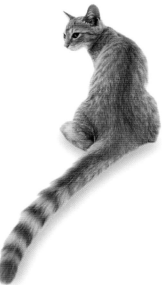

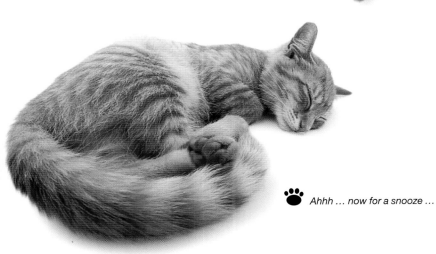

Ahhh … now for a snooze …

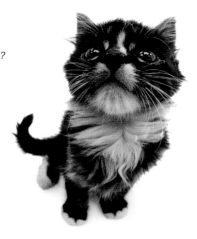

 Want to fight?

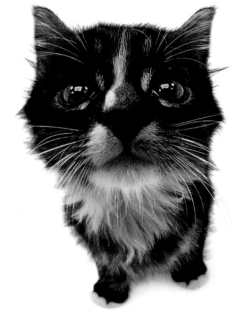

 What are you looking at?

MAINE COON

The playful and affectionate Maine Coon has become one of the world's most popular breeds, despite losing ground to the Persians in the early part of the twentieth century.

The breed's unusual name comes from Maine, America's "Pine Tree State" on the eastern seaboard, where this cat is thought to have originated, and from the fact that people at one time believed that feral cats in Maine had mated with native racoons. That, of course, was a complete myth, but the name stuck nevertheless. Maine Coons probably evolved as a result of local cats breeding with foreign types that arrived in the area aboard trading ships in the nineteenth century.

Certainly, the Maine Coon retains one of the major characteristics of American cats in that it is a large breed, many examples growing to more than twice the weight of an average household cat.

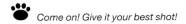 *Come on! Give it your best shot!*

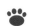

35

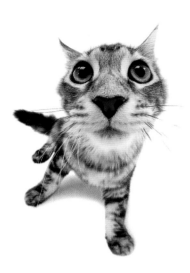

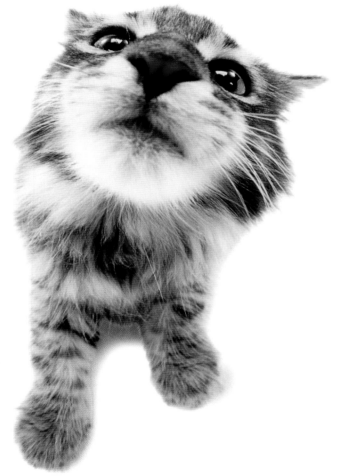

 No, I won't play with you until you apologize for biting my tail.

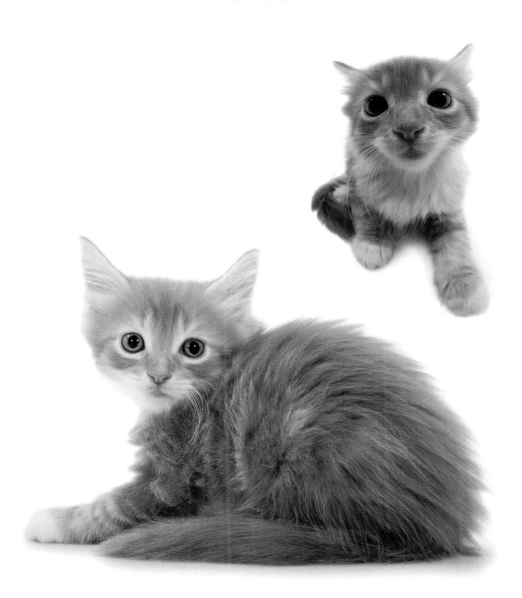

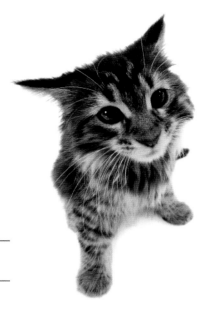

 He reckons this is the easiest way to tunnel up under a duvet while you're asleep …

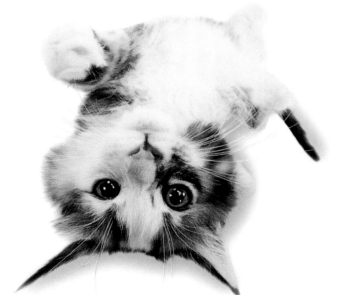

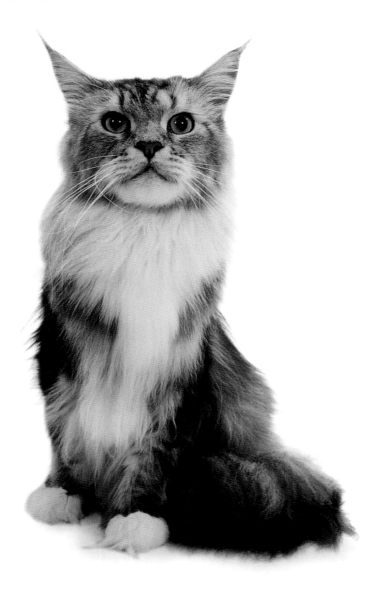

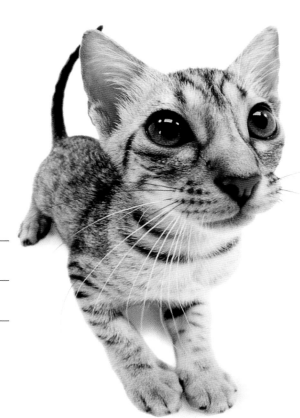

OCICAT

First reared in America as a cross between Siamese and Abyssinian breeds, the Ocicat takes its name from the ocelot, a small South American leopard that has been prized for its luxurious coat since the time of the Aztecs. Hunting and the loss of its natural habitat to deforestation have sadly made the ocelot an endangered species.

The markings of the first Ocicat kittens (bred in Michigan in the 1960s) were what inspired its breeders to adopt the name: the cat's spots and stripes closely resemble the markings of the ocelot. Happily, the Ocicat, although still quite rare, is not facing the same danger of extinction as its namesake.

These are extremely easy cats to befriend. They have a playful nature and a love of curling up in a warm lap – although the male, which is much larger than the female, can be quite a heavy couch partner. Ocicats are also famous for being far more tolerant towards children than are many other breeds, making them ideal family pets.

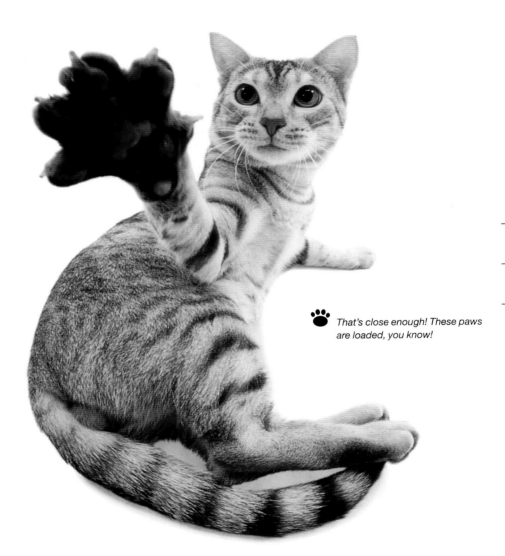

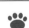

41

That's close enough! These paws are loaded, you know!

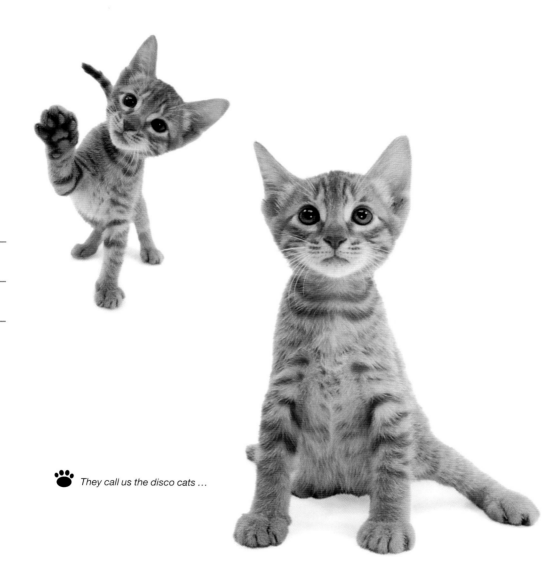

They call us the disco cats …

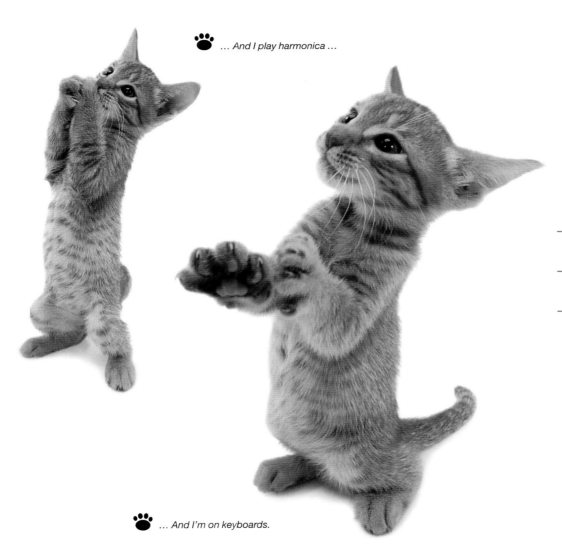

... And I play harmonica ...

43

... And I'm on keyboards.

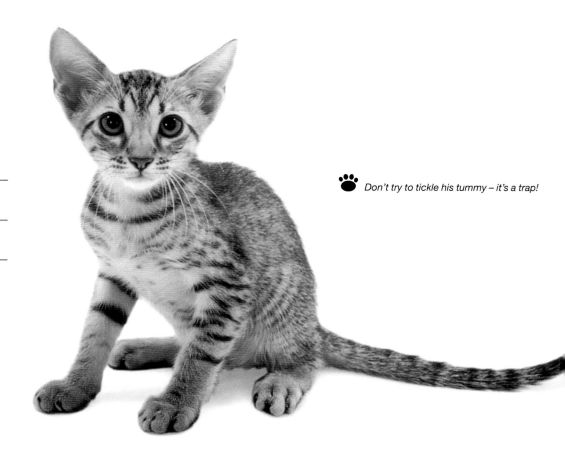

Don't try to tickle his tummy – it's a trap!

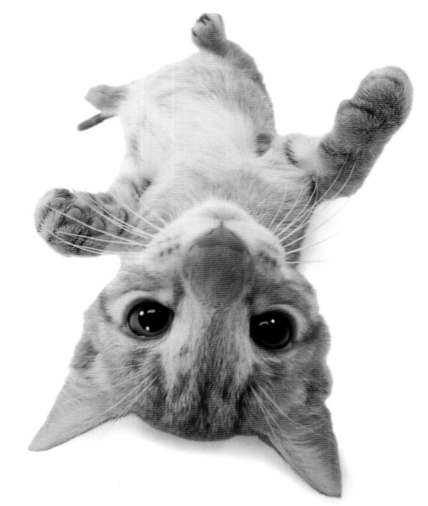

45

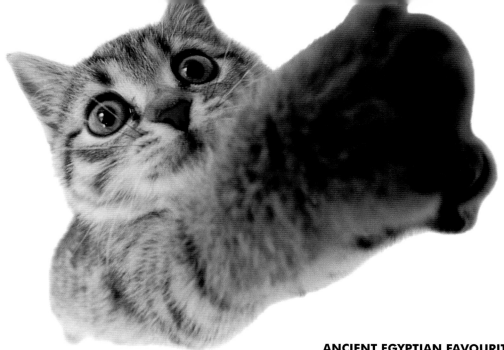

ANCIENT EGYPTIAN FAVOURITES

The cat was undoubtedly the last of the wild
animals to be domesticated, although some
people would maintain that even today cats
remain thoroughly independent. The Ancient
Egyptians used cats to guard their grain stores
from rodents and to help keep their homes free
from other such vermin, but they also trained
cats to help them hunt birds.

Such was their affection for cats that they
even worshipped a cat goddess called Bastet.
They also mummified cats, giving them a
proper burial when they died. The cats' owners
would shave off their own eyebrows to show
their grief. In one Egyptian cat cemetery more
than 300,000 cat mummies were discovered!

 Ha! You can't keep that camera strap out of my reach forever, you know!

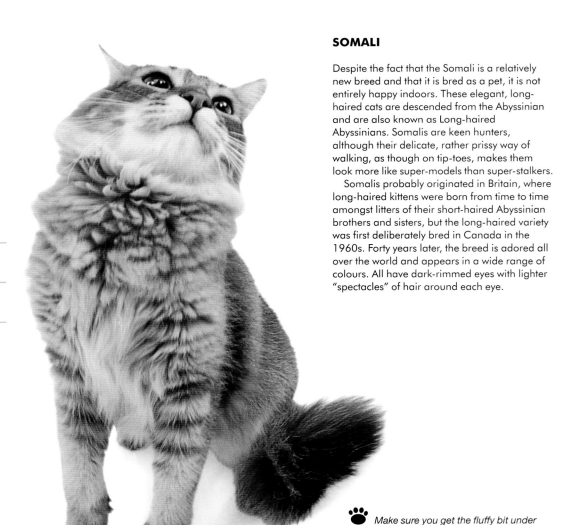

SOMALI

Despite the fact that the Somali is a relatively new breed and that it is bred as a pet, it is not entirely happy indoors. These elegant, long-haired cats are descended from the Abyssinian and are also known as Long-haired Abyssinians. Somalis are keen hunters, although their delicate, rather prissy way of walking, as though on tip-toes, makes them look more like super-models than super-stalkers.

Somalis probably originated in Britain, where long-haired kittens were born from time to time amongst litters of their short-haired Abyssinian brothers and sisters, but the long-haired variety was first deliberately bred in Canada in the 1960s. Forty years later, the breed is adored all over the world and appears in a wide range of colours. All have dark-rimmed eyes with lighter "spectacles" of hair around each eye.

Make sure you get the fluffy bit under my chin. It's really cool!

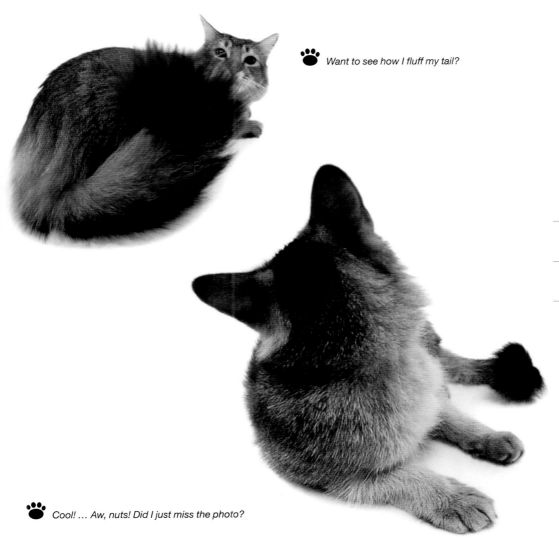

Want to see how I fluff my tail?

49

Cool! … Aw, nuts! Did I just miss the photo?

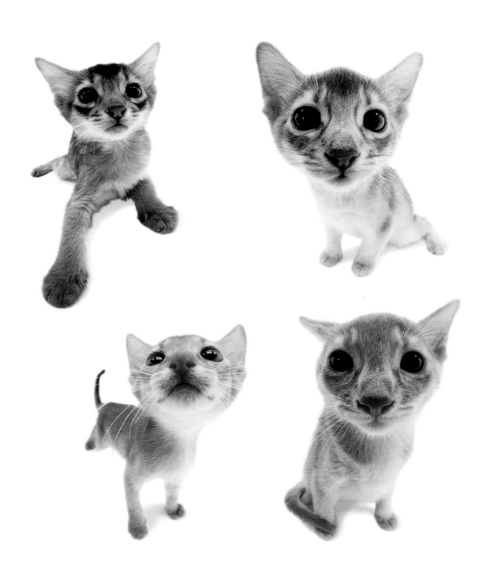

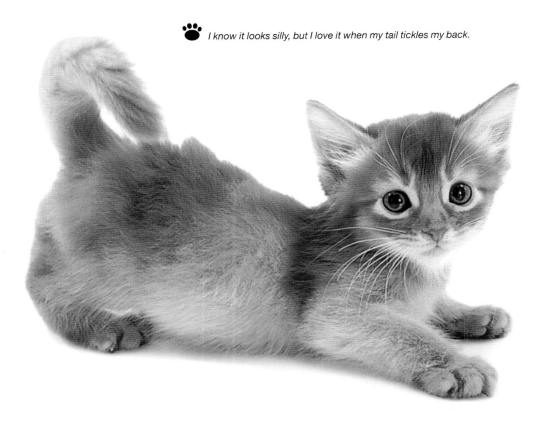

I know it looks silly, but I love it when my tail tickles my back.

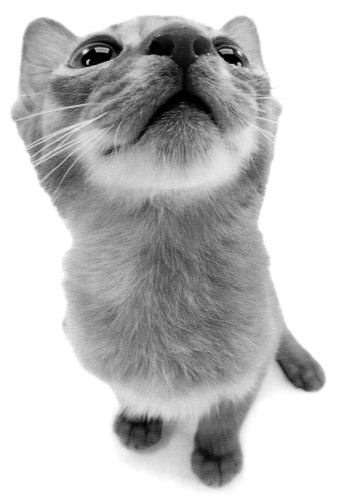
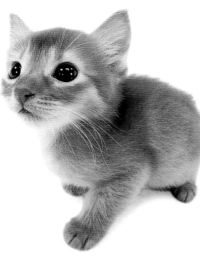

🐾 *How does she make her tail vanish like that?*

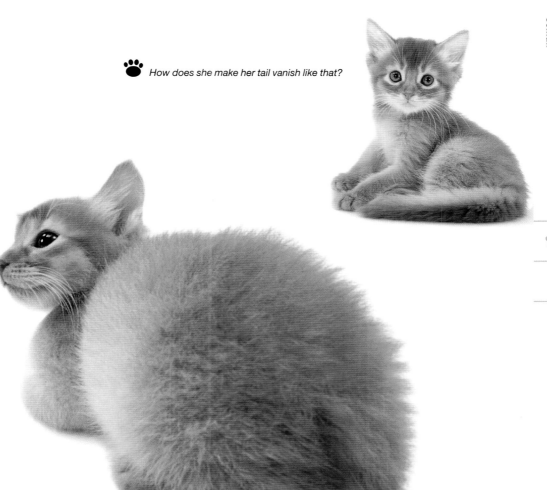

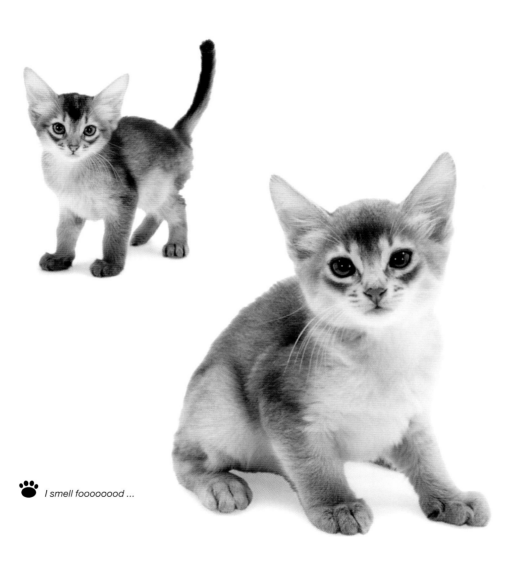

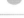

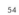 *I smell foooooood ...*

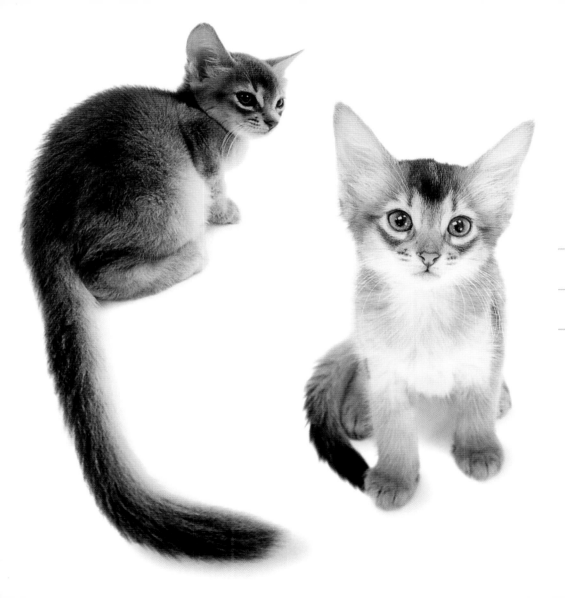

 He thinks he's a yeti ...

THE CAT'S SIXTH SENSE

Cats are often said to have a "sixth sense" that warns them of impending danger, and there is plenty of evidence to show that they are sensitive to the onset of natural disasters. On 7 May, 1976, cats in the Friuli region of northern Italy began scrabbling to get out of houses during the day. At 9.00pm a massive earthquake hit the area, devastating 11 villages. In March 1944, a cat called Toto woke his owner during the night by scratching at his face. The man and his wife left their home just before Mount Vesuvius erupted and their house was destroyed by lava.

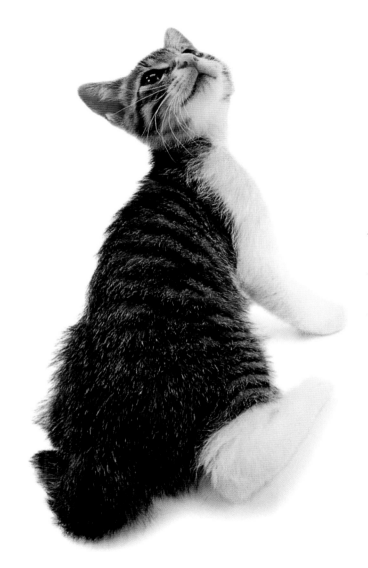

57

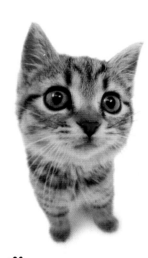

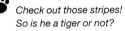 *Check out those stripes!*
So is he a tiger or not?

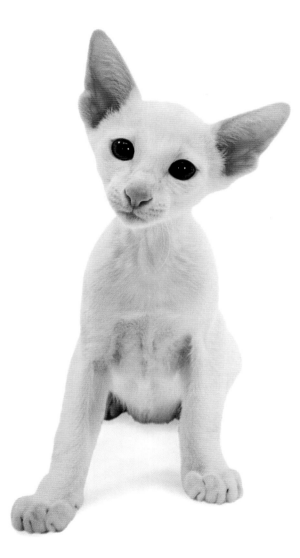

ORIENTAL SHORTHAIR

Playful and demanding of attention, the Oriental Shorthair looks and behaves very much like a Siamese, with which it shares its ancestry. It has the same short coat and the same narrow, triangular face with pointed ears that extend the line of the face outwards. And like the Siamese, it has an inquisitive nature and a way of calling for attention in a very loud voice. It also retains the Siamese characteristics of small, round paws and hind legs that are noticably longer than its front ones. However, the Oriental does not normally have the Seal Point markings usually associated with Siamese, nor, with one remarkable exception – the Oriental White – does it have the latter's blue eyes.

In the 1950s, attempts to breed different varieties of Oriental in the USA and Britain (where these cats were once known as the far less glamorous Foreign Shorthair) led to the establishment of what are now distinctly different breeds, such as the Havana Brown.

Hey! I can see myself in your camera thingy!

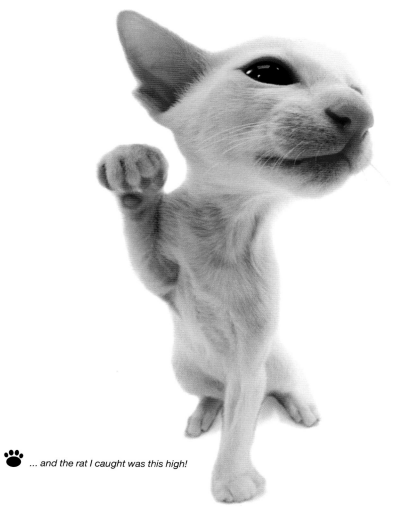

 ... and the rat I caught was this high!

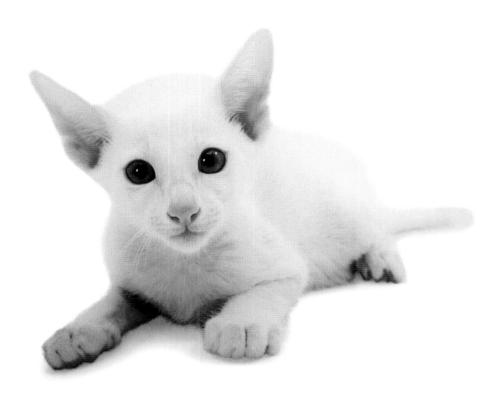

61

 He tells a great story – but you can't believe a word of it!

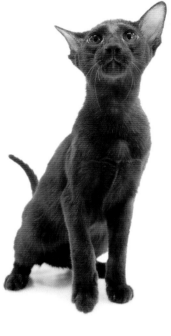

 He bit my paw!

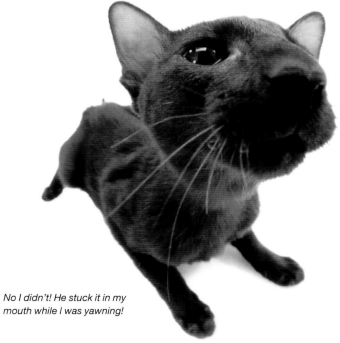

 No I didn't! He stuck it in my mouth while I was yawning!

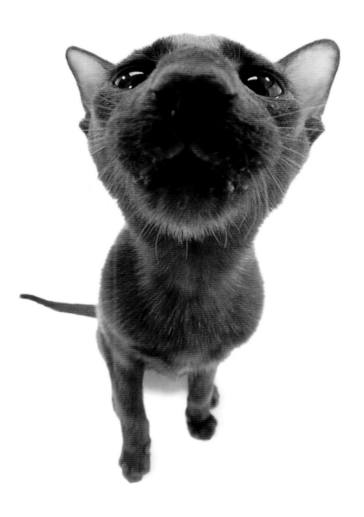

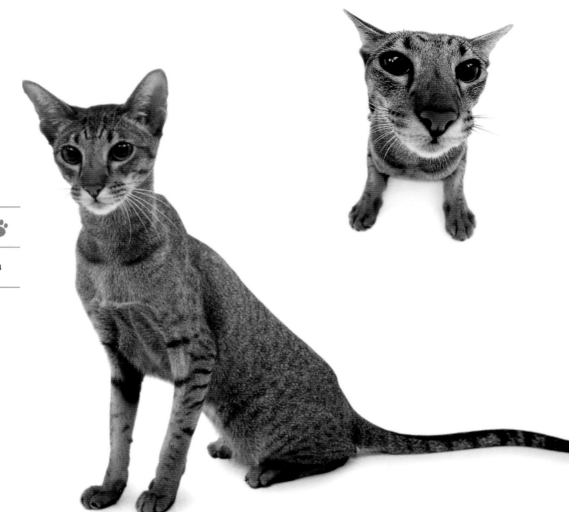

If she keeps on eating her own tail, will she eventually disappear completely?

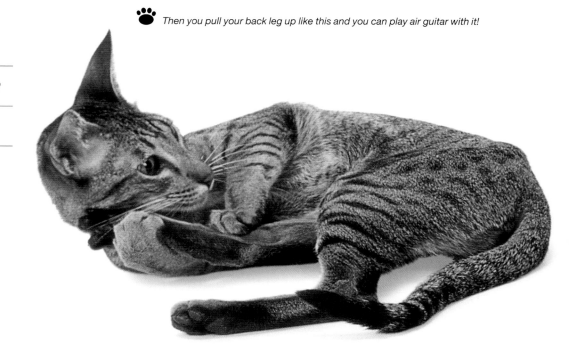

Then you pull your back leg up like this and you can play air guitar with it!

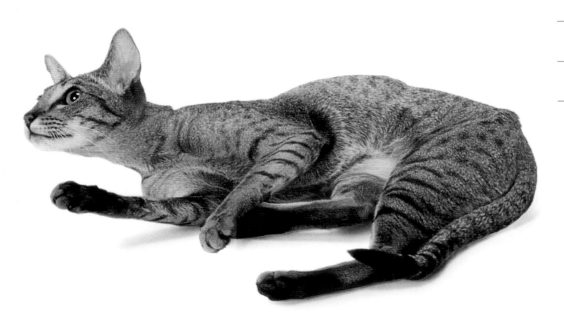

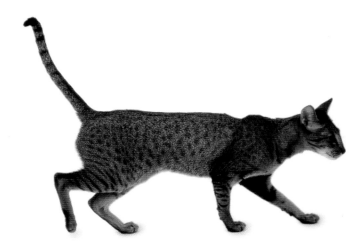

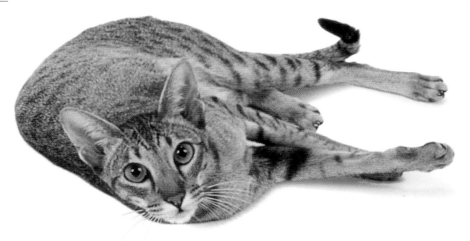

I hope you're not expecting me to do all that silly stretching and stalking, too?

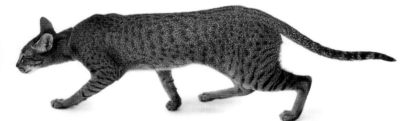

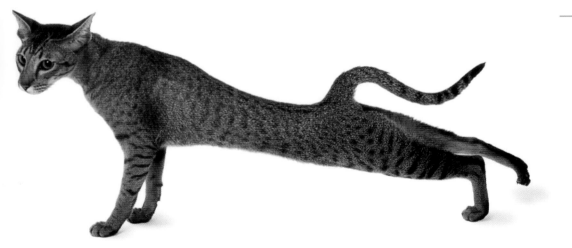

THE CAT FESTIVAL OF YPRES

Every three years in Ypres in Belgium, there is a cat festival, where the people of Ypres parade through the streets dressed as cats. In a ceremony that dates back to the twelfth century, when the procession was used to rid the area of witches, a giant statue of Bastet, also known as the Norse goddess Freya, is towed through the town to the Cloth Tower. Here, there is a ceremonial burning of witch effigies before the parade's cat queen climbs to the top of the Cloth Tower with her jesters. Until 1817, when the practice was outlawed, real cats were hurled to their deaths from the tower. Nowadays, thankfully, they throw velvet cats down to the crowds below instead.

🐾 *Wow! I never knew you could see so far inside an ear!*

MUNCHKIN

Munchkins have been a recognized cat breed for more than 10 years but they still fuel the fires of one of the cat world's greatest debates. Should the deliberate breeding of this type have been allowed?

Munchkins first appeared in Louisiana more than twenty years ago. At that time, they were abnormal cats with unusually short legs. Miniature breeds of dog have been produced for centuries, and there are inherent physical problems with many of them, but the Munchkin was the first dwarf cat. It is to be hoped that the more supple body of the cat will be better able to cope should its shorter legs tend to cause the sort of hip and spinal problems sometimes seen in small dogs.

The Munchkin's short legs may be a freak of nature, but owners maintain that the cats are healthy and happy, clowning like kittens even when they should be old enough to know better. Munchkins come in many different colours and have bushy coats that require a good deal of grooming, but their endearing personalities help to make this less of a chore and more of a silly game!

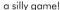

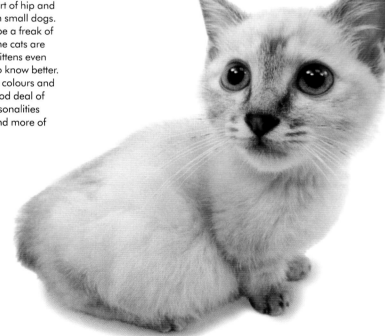

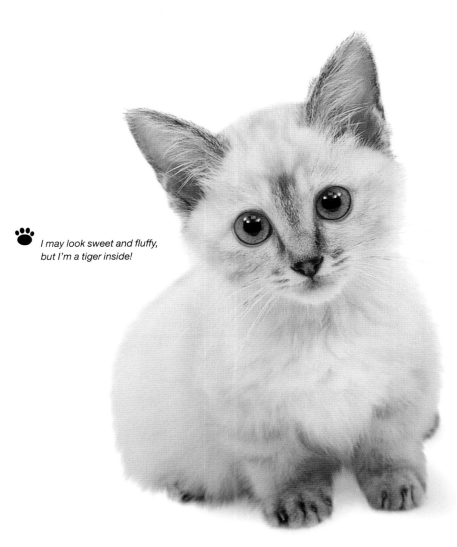

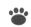

*I may look sweet and fluffy,
but I'm a tiger inside!*

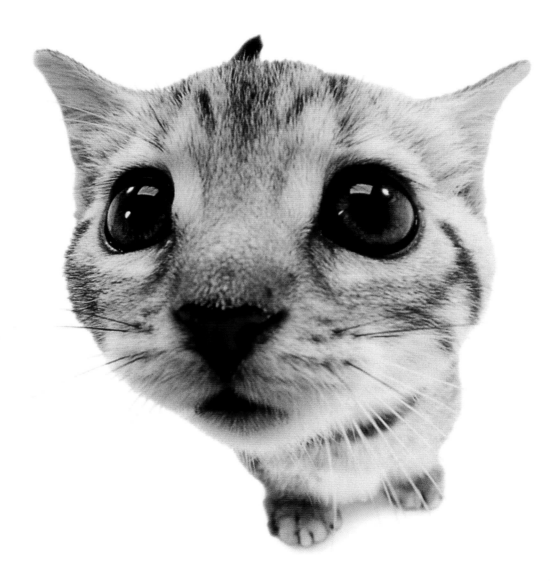

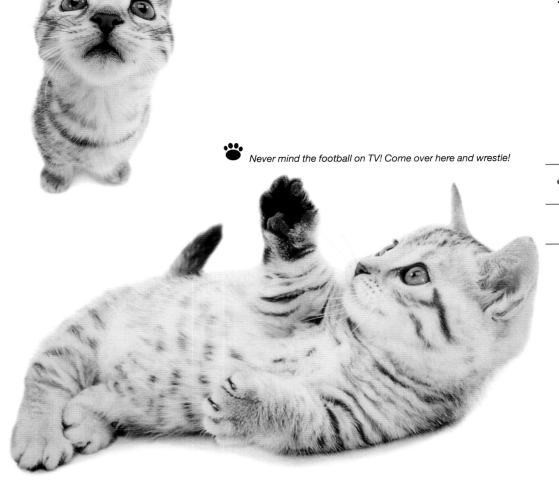

🐾 *Never mind the football on TV! Come over here and wrestle!*

🐾

75

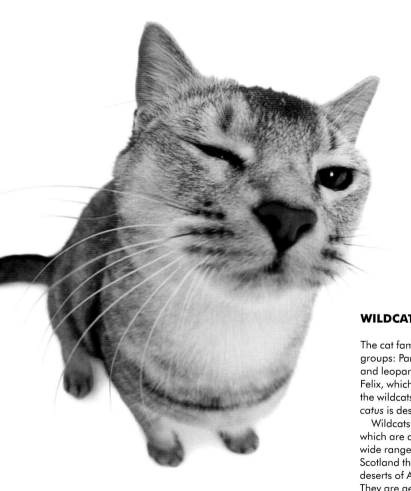

WILDCATS AND DOMESTIC CATS

The cat family can be divided into two main groups: Panthera, which includes the lion, tiger and leopard – the big cats that can roar – and Felix, which includes the puma, ocelot, lynx and the wildcats from which our domestic cat, *Felis catus* is descended.

Wildcats – not to be confused with feral cats, which are domestic cats living wild – inhabit a wide range of environments from the forests of Scotland through Europe to the jungles and deserts of Africa, the Middle East and Asia. They are generally much larger than domestic cats, but are so closely related that they can and do interbreed when wildcats find themselves living close to towns or villages.

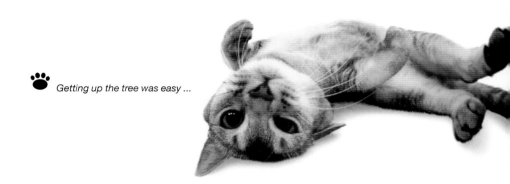

Getting up the tree was easy ...

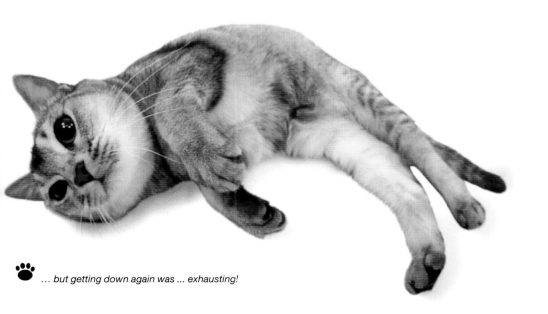

... but getting down again was ... exhausting!

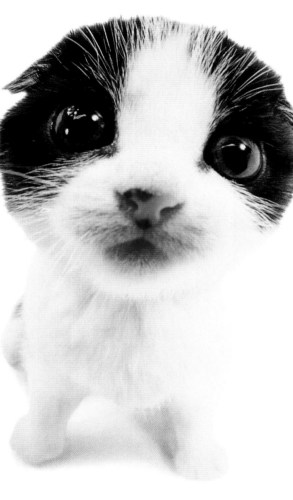

SCOTTISH FOLD

Although it is thought that the Scottish Fold may be descended from Chinese cats that were brought to Britain in the late nineteenth century, the modern Scottish Fold can safely trace its ancestry back only as far as the 1960s in Tayside in Scotland.

The cats that were brought to Britain by traders more than a century ago caused something of a sensation when they arrived, as no cat breed had previously been seen with ears that folded forwards over its head. The novelty appears to have worn off, however, as this feature seemed to die out until a Perthshire farm cat called Susie produced a kitten with flattened ears and the Scottish fold breed was established.

Apart from looking like cats that have been wearing hats, the other notable features of Folds are their large, round eyes, stocky back legs and thick tail. Their fur is short and they appear in all different colours and patterns.

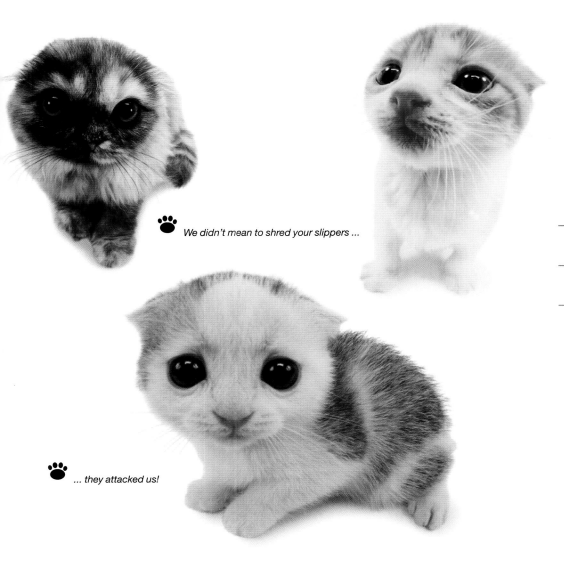

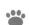

We didn't mean to shred your slippers ...

... they attacked us!

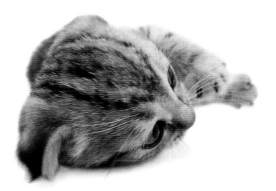

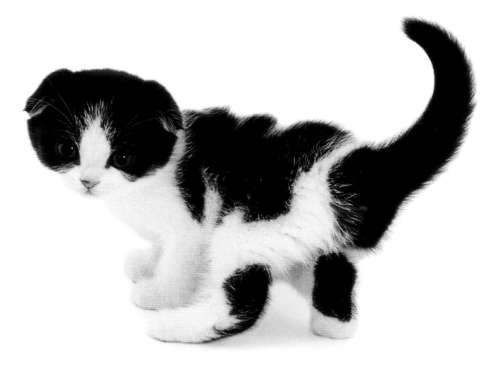

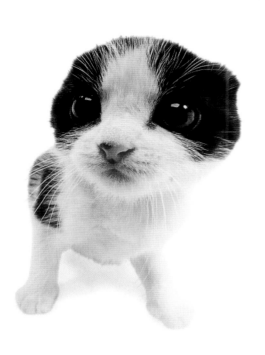

Hanging by one paw from the window ledge ...
I could use some help here, guys ... Guys?!

HUNTING OR PLAYING?

All cats have a natural instinct to hunt prey. That doesn't mean that all cats will go out and bring home mice, frogs or small birds, but many will. Often they will present these trophies to you because they want you to see how clever they have been, but it's difficult to feel proud of your pets when they drop a half-dead mouse at your feet!

Cats that spend most of their time indoors need furry or feathered toys to help them satisfy their hunting instinct. They will pounce, capture and "kill" even a ping-pong ball just as though it were real prey, so it's vital that you keep a few toys around to help your cat lead a happy life.

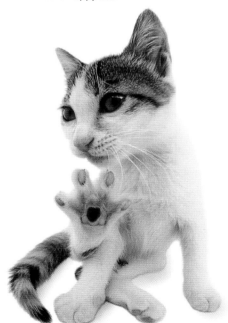

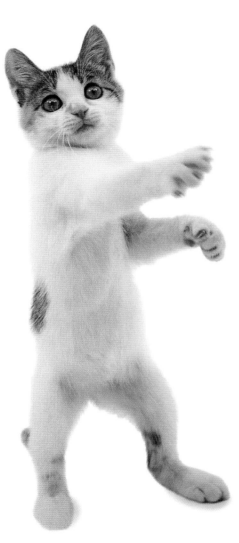

Mmmmmm ... if only all ducks were so easy to catch.

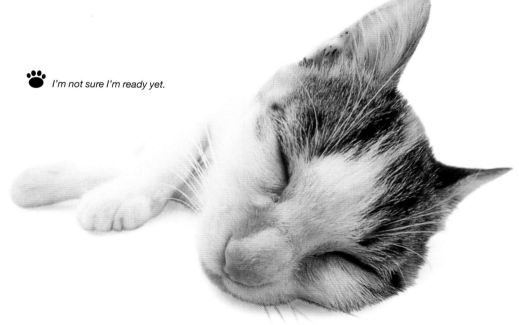

 Is it my turn for a photo?

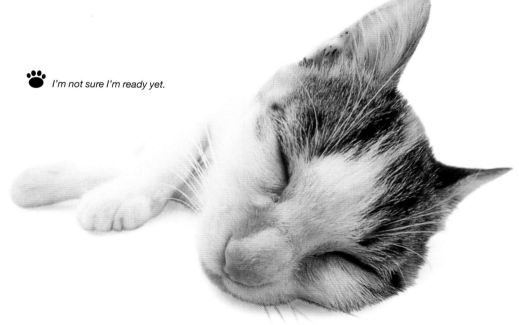 *I'm not sure I'm ready yet.*

Have you ever had one of those mornings when you just couldn't get your eyes open?

NORWEGIAN FOREST CAT

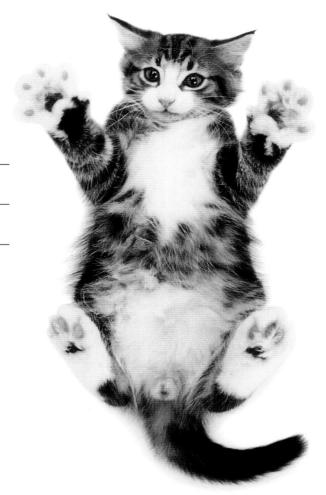

Marauding Viking raiders, storming ashore from their longboats, swinging their great battleaxes and laying whole villages to waste, hardly seem suitable candidates for the title of the world's foremost cat-fanciers. Not all Viking travellers were ferocious warriors, however. The Vikings established trade routes to Europe and Asia, bringing home, amongst other things, cats. That was around 1,000 years ago, but the breeds that flourished in the Vikings' Scandinavian homelands – large cats with long, thick fur to see them through the harsh winters – were undoubtedly the ancestors of today's Norwegian Forest Cat.

The "Wegie", as it also sometimes known, is a strong, clever cat, happy to live indoors but happier still outside, where its dense double coat – a water-resistant top layer and a warm, woolly, bottom layer – keeps out the worst weather, and where it can indulge its passions for climbing and hunting. Wegies have even been known to go fishing in brooks.

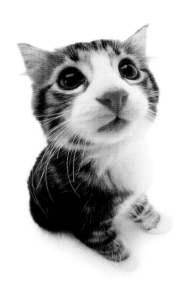

 If you were a mouse, I'd have you on toast!

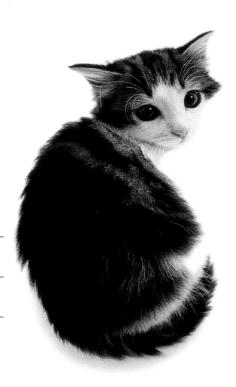

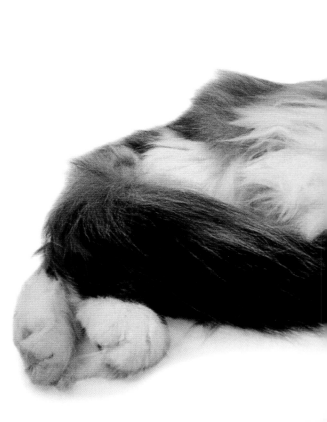

She wouldn't be sleeping so happily if she knew we'd got her surrounded!

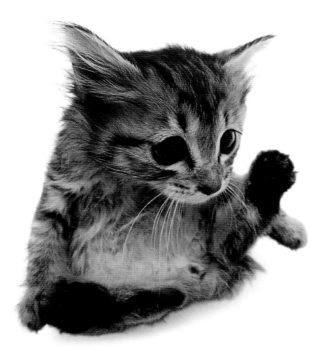

PREHISTORIC ANCESTORS

The kitten that you see chasing butterflies in the garden or losing a mighty battle with a ball of twine may not look like one of the most highly evolved carnivores on the planet, but we can trace his ancestry back many millions of years. The cat family developed from a species called *Pseudoailanus* (meaning "false cat"), which lived around 25 million years ago. This creature had fur and teeth, ate only meat and walked on tip-toe just as that kitten in the garden does.

 It's no good. I can't do it …

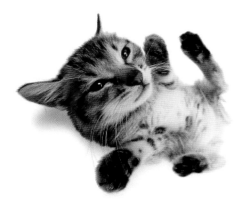

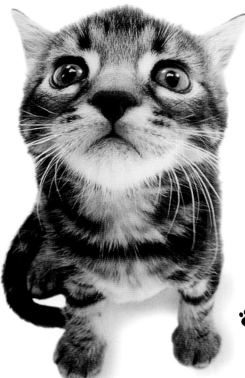

Come and play or I'll claw my way up your trouser leg.

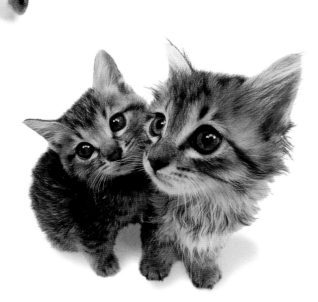

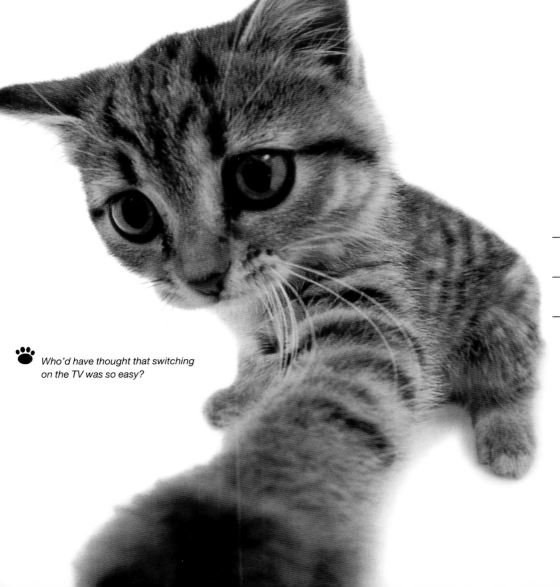

Who'd have thought that switching on the TV was so easy?

PERSIAN

Europeans knew nothing of the noble Persian until the early seventeenth century when the breed, also know simply as the Longhair, was first imported from Persia (now Iran) to Italy. Its long, luxurious coat quickly made it a very fashionable house pet among the chic social elite in its new homeland.

With its large head, drooping cheeks and big round eyes, the Persian often appears to have a grumpy expression. In fact, these cats are normally quite placid and affectionate – a result of having been bred as house pets for so long. While some cat lovers might think the grumpy look – accentuated in the tabby by "frown-line" markings on the forehead – rather unfortunate, others positively covet it. The flat-faced characteristics are especially prized in what are known as "Peke-faced Persians", which are bred specifically to look like Pekingese dogs.

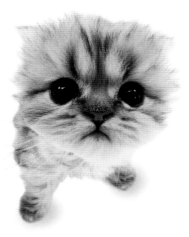

 Sorry. He says the draught keeps blowing him over ...

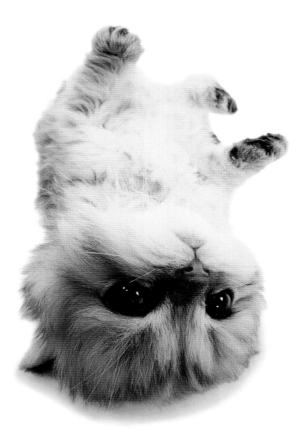

95

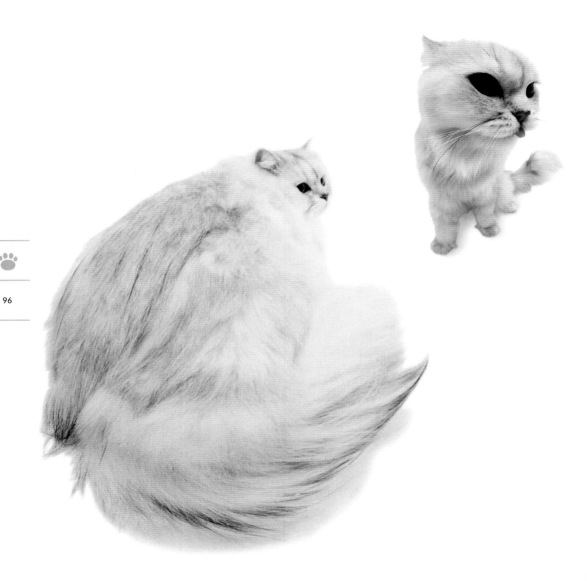

 I admit it ... this paw may have left some dirty prints on your pillow.

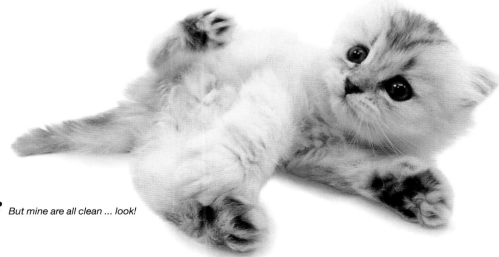

 But mine are all clean ... look!

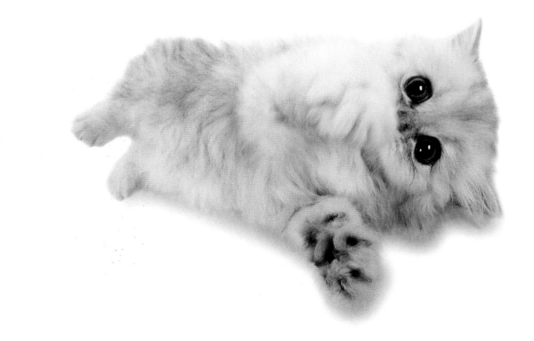

 He's still not figured out that for running it's "paws on the ground."

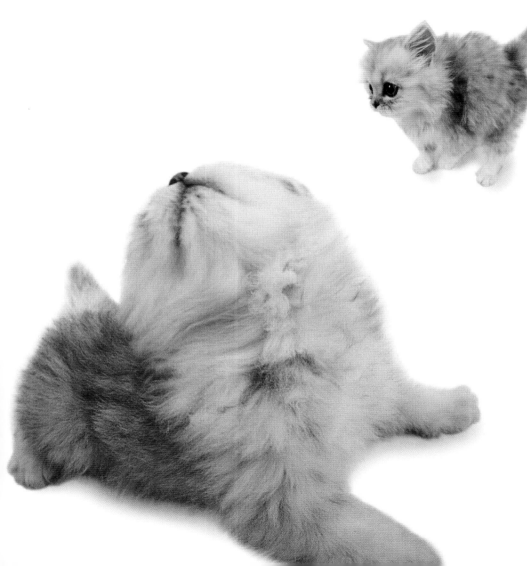

99

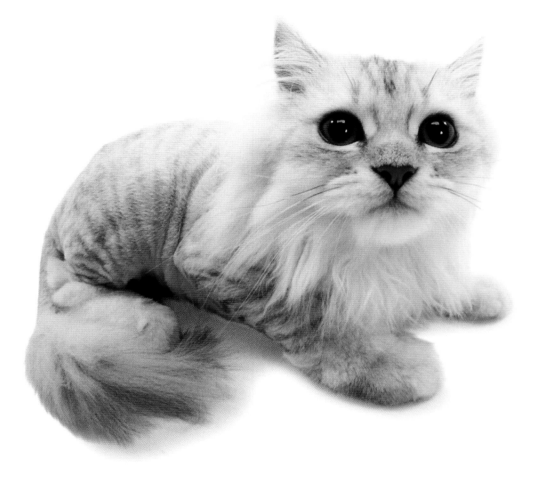

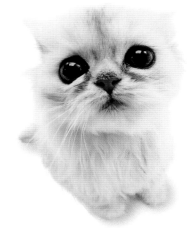

 Hey! The bird went up in the air! They can fly!

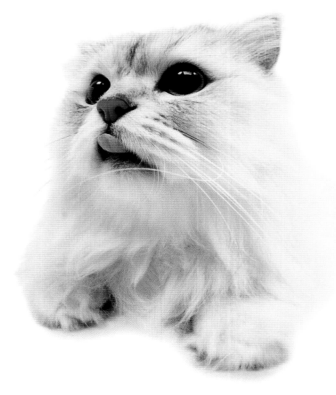

 That's just not fair!

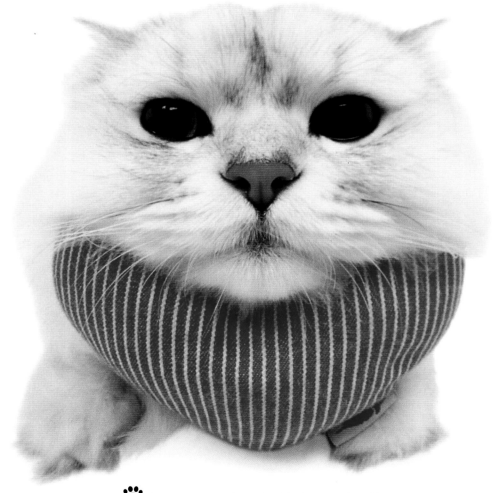

I want everyone to know that this photo wasn't my idea ...

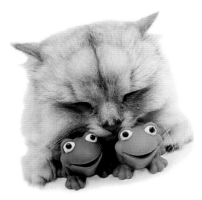

My favourite froggies ...

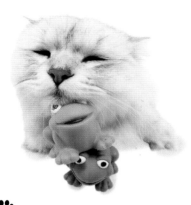

Whoops! They're getting a bit lively!

103

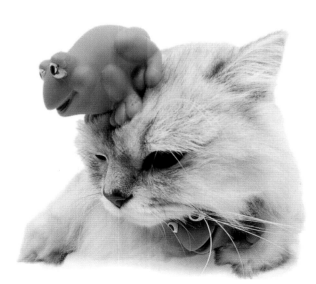

Hey! Where did he go?

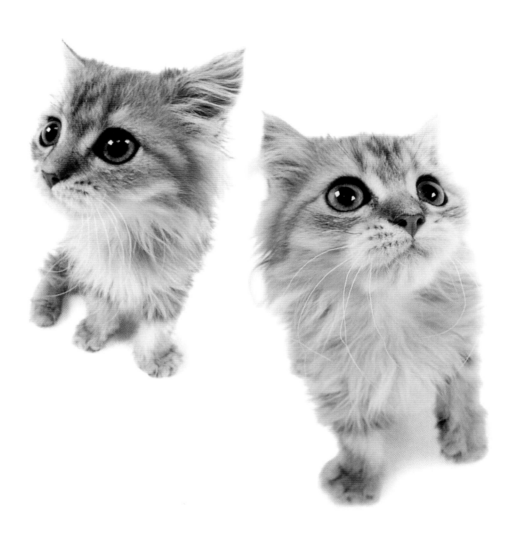

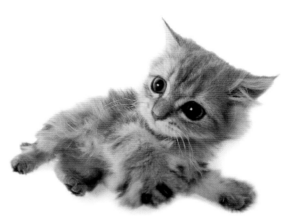



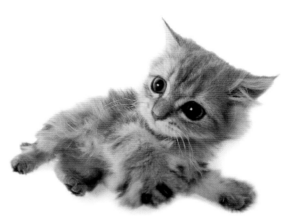

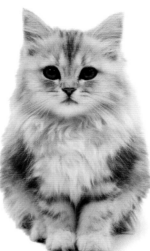

I don't know why you couldn't sit still for a proper photo …

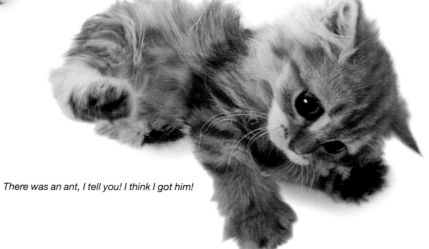

There was an ant, I tell you! I think I got him!

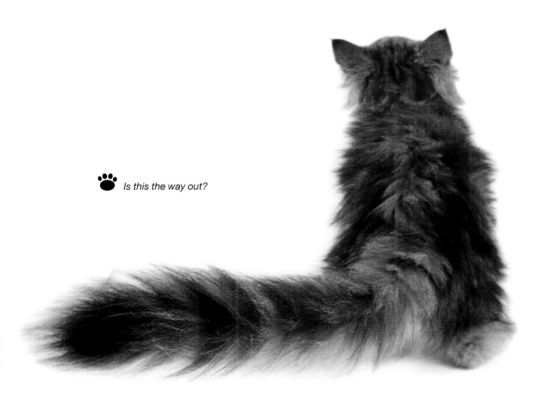

Is this the way out?

BURMESE

Although there are records of cats called *rajahs* who lived with Buddhist monks in Burma (now Myanmar) six centuries ago, all modern Burmese cats can trace their ancestry back to a cat called Wong Mau, who was brought from Rangoon to California by US Navy psychiatrist Joseph Thompson in 1930. Wong Mau was crossed with a Siamese to produce the first of what were to become two different types of Burmese. In America, breeders favoured a rounded look to the head and eyes, even a rounded physique, whereas when the Burmese came to Europe, enthusiasts of the breed preferred a more angular look.

At first the Burmese was only ever brown, known as sable, but from the mid 1950s, different colours began to appear. In America, the range of colours felt to be acceptable is not as wide as it is in Europe but, while the differences between the two types continue to grow, American and European Burmese will always have in common an even-tempered, fun-loving nature that is an inherent part of the breed's charm.

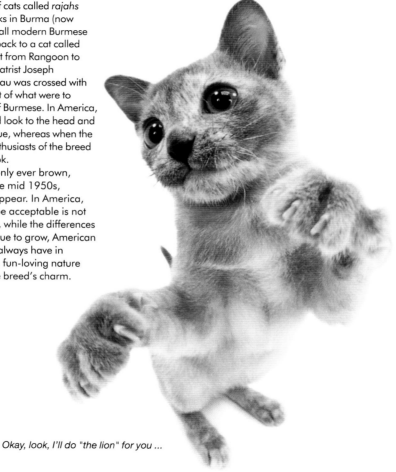

 Okay, look, I'll do "the lion" for you ...

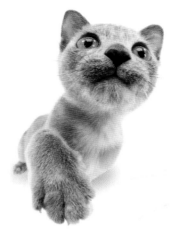

 ... and I'll give you a paw to shake ...

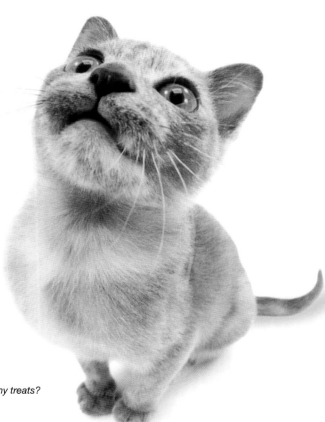

 ... now can I have one of those fishy treats?

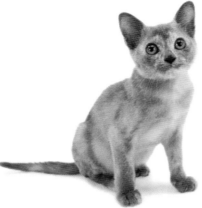

 What's that buzzy, flying thing?

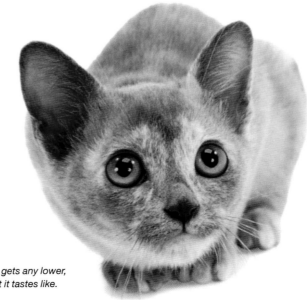

 *I don't know, but if it gets any lower,
I'll let you know what it tastes like.*

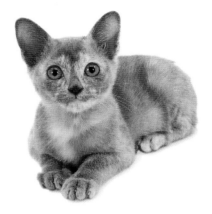

Have you ever had the feeling that there's something sneaking up behind you?

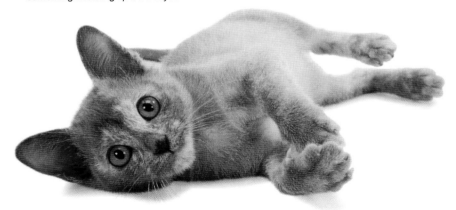

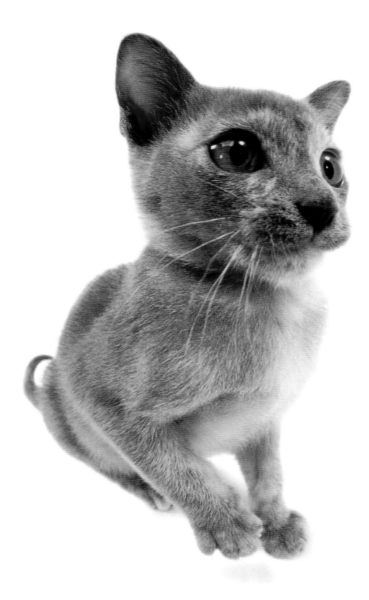

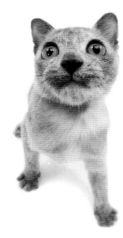

Check out those boxing paws. This kid's going all the way – he's a champ, I tell you!

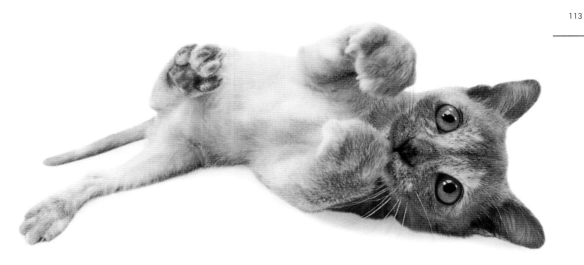

RAGDOLL

Ragdolls have earned themselves a strange reputation since they were first bred by Californian Ann Baker in the 1960s. People have come to believe that they feel no pain, have no fear and will not fight with other cats. While these are essentially placid and extremely friendly cats, owners can testify that the myths about the fearless, non-combatant Ragdoll that knows no pain are groundless.

The story of how these sophisticated cats came to be called this rather incongruous name is, however, apparently true. Ann Baker gave the name Ragdoll to the first kittens she bred because, when she picked them up, rather than looking for an affectionate pat or hissing and spitting as other cats might, they simply went limp like rag dolls. Don't be fooled by the name, though – these cats are not limp and listless. Rather, they are large, strong and quite demanding, loving nothing better than to be groomed or petted.

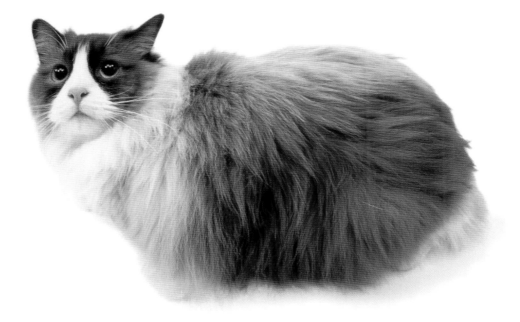

Please tell me I didn't go limp as a kitten ...

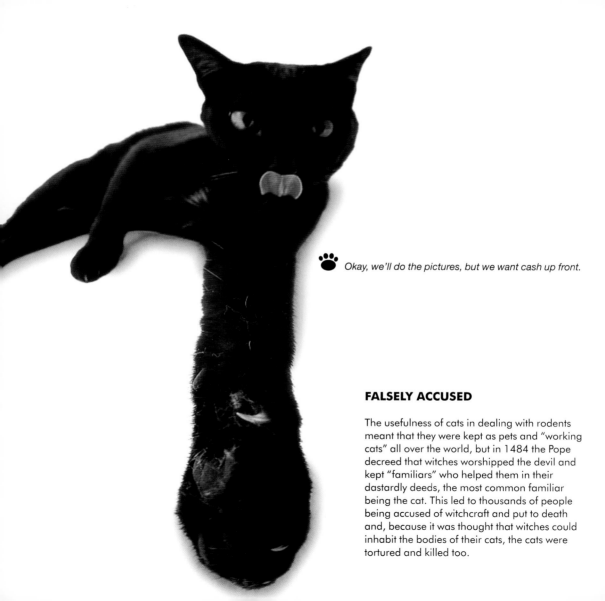

Okay, we'll do the pictures, but we want cash up front.

FALSELY ACCUSED

The usefulness of cats in dealing with rodents meant that they were kept as pets and "working cats" all over the world, but in 1484 the Pope decreed that witches worshipped the devil and kept "familiars" who helped them in their dastardly deeds, the most common familiar being the cat. This led to thousands of people being accused of witchcraft and put to death and, because it was thought that witches could inhabit the bodies of their cats, the cats were tortured and killed too.

AMERICAN SHORTHAIR

A large, strong cat, the American Shorthair is at its most magnificent in the dazzling silver-and-black markings of the Silver Tabby, but there are more than 80 other colours and colour combinations within the breed.

At the first large, organized cat show in America, held in Madison Square Garden, New York, in 1895, these cats were simply called Shorthairs, but they later became known as Domestic Shorthairs to distinguish them from foreign breeds.

The very first all-American bred Shorthair was a Black Smoke called Buster Brown, registered in 1904. Buster was an adopted street cat whose "Black Smoke" coat looked a sleek, solid black when he was sitting peacefully, but shimmered when he moved as the lighter colour underneath showed through.

In the early 1960s, American breeders began pressing for a name change, as the "Domestic" label had connotations of a common house cat rather than a pedigree breed and this was seen to be damaging its popularity. The cats finally became the American Shorthair and delighted patriotic breeders when a glamorous Silver Tabby won the 1965 United States Cat of the Year award.

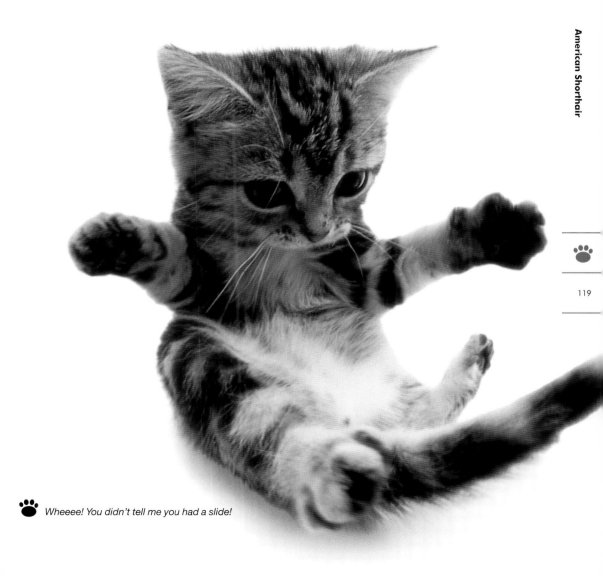

🐾 *Wheeee! You didn't tell me you had a slide!*

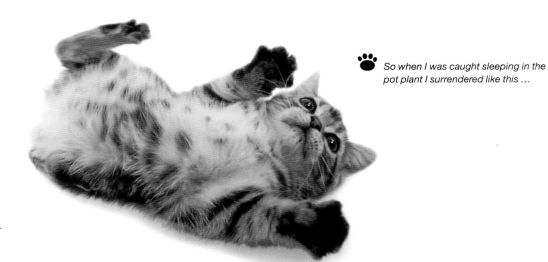

So when I was caught sleeping in the pot plant I surrendered like this ...

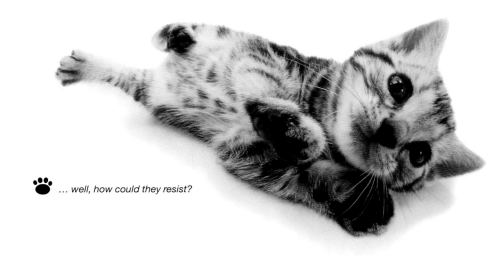

... well, how could they resist?

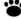 *Keep up the injured paw act –
she's reaching for the cat biscuits.*

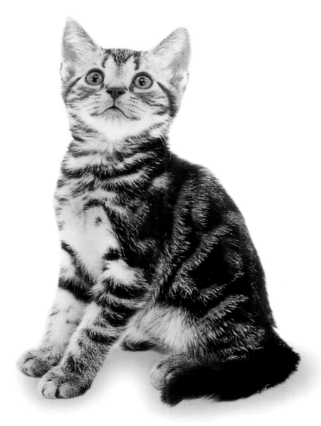

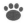

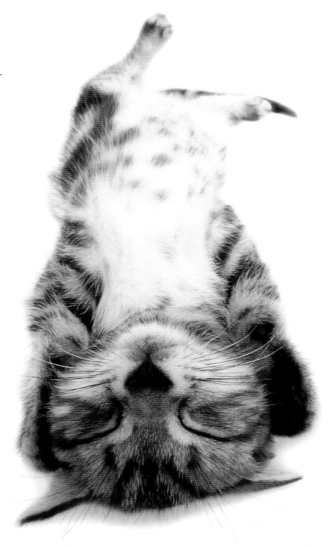

Mmmmm ... back ...

122

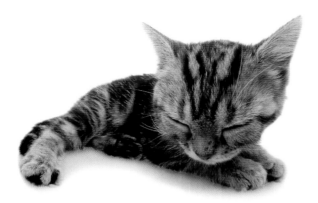

 ... front ...

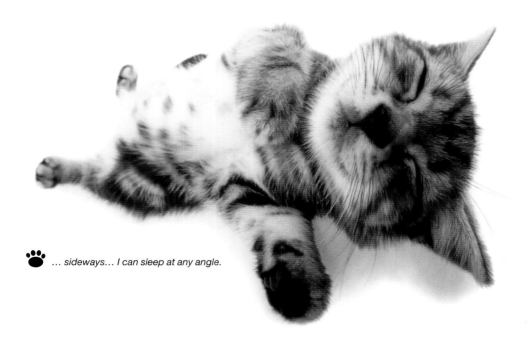

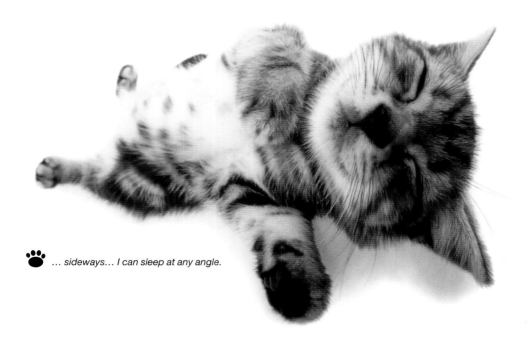 *... sideways... I can sleep at any angle.*

 It's going to be a brilliant catch!

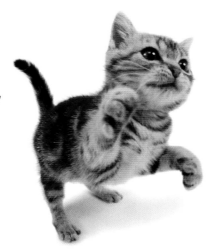

 It's being thrown from all the way across the room!

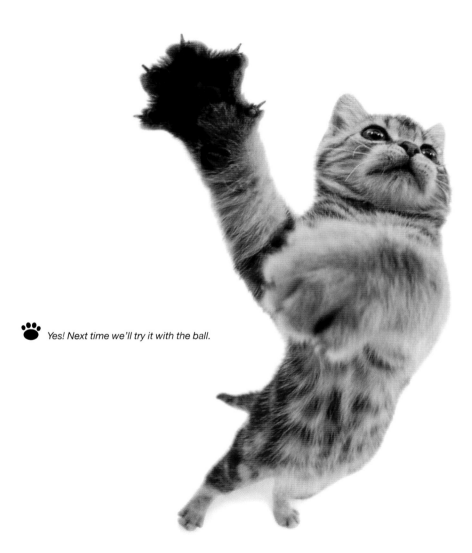

125

Yes! Next time we'll try it with the ball.

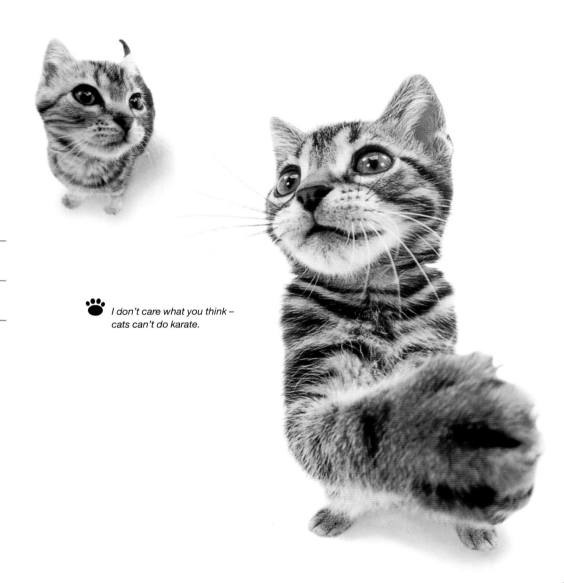

I don't care what you think – cats can't do karate.

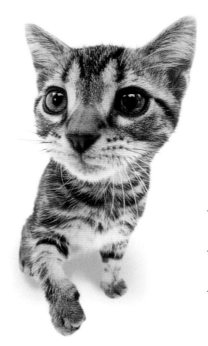

127

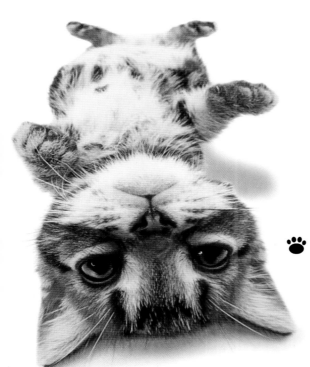

 They told me I would always land on my feet!

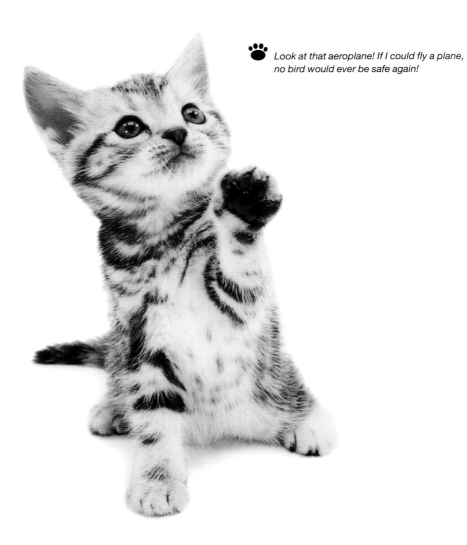

Look at that aeroplane! If I could fly a plane, no bird would ever be safe again!